MIKE MCCARTNEY'S
NORTH HIGHLANDS

Woodland Publishing

Mike McCartney's North Highlands

Photographs by Mike McCartney

Woodland Publishing

ISBN 978-1-905547-09-8

Woodland Publishing Limited
Publisher: Guy Woodland

Photography and writing: Mike McCartney
www.mikemcartney.co.uk

Chapter introductions: Mike Merritt

Design concept: Josh McCartney
www.group-hug.com

Proof reading: Judy Tasker

Portrait photography of Mike McCartney: Sonny McCartney
www.sonnyme.com

First published in 2009 by Guy Woodland
as a Woodland Publishing imprint.

Printed in Barcelona by Graficas 94

Studio and office:
No 2 The Old Stables, Charles Road, Wirral, CH47 3BP. UK

Tel: + 44 (0) 151 632 3280 *Skype*: +44 (0) 151 324 1273

e.mail: info@cities500.com - *www.cities500.com*

Acknowledgements

Mike met many people on his adventure around the North Highlands and we would like to thank some of them.

Mike Merritt – for developing the idea, for his assistance in patiently chauffeuring Mike around the North Highlands and for introducing him to so many fascinating people ... and places.

Jeremy Gilbert at Nikon – for his and Nikon's continued support of Mike's work.

Highlands and Islands Enterprise and Eann Sinclair – for having the vision to involve Mike in the Year of Homecoming.

A very special acknowledgement of thanks goes to Marjorie Walker who has personally sponsored the book and without whose generous support the project would not have gone ahead.

Mike McCartney's
North Highlands

CONTENTS

MIKE MERRITT

EXHIBITION CO-ORDINATOR

Through the years, the North Highlands of Scotland have fascinated and drawn in artists from all over the world.

From LS Lowry, who painted Wick and Thurso, to the poet Norman MacCaig and the writer Neil Gunn – just to mention a few – art has tried to imitate life in this beautiful stretch of the British Isles.

Following in that great tradition is Mike McCartney. For two weeks in April, 2008, McCartney recorded his impressions of an area that he admits is almost impossible to capture fully. That is part of its elusive allure.

But this resulting photographic exhibition – Mike McCartney's North Highlands – is another important contribution to the eternal quest to define one of the most stunning areas in the world. The North Highlands are impossible to capture in a single phrase, painting or photograph.

That is because the light, the seasons and the people are constantly changing on a landscape that is timeless – yet, simultaneously shaped by the past, absorbed in the present and embracing the future.

It is to this physical and social landscape that McCartney has brought his sharp eye and keen intelligence – but also his trademark Scouse humour, well-honed from his earlier days in the satirical group, the Scaffold.

McCartney was commissioned by Highlands and Islands Enterprise to highlight the area's beauty and diversity and as a place in which to live, to work and to escape. His journey was an epic one and his days long. But his sheer enthusiasm and passion for his art – and The North Highlands – shines through this stunning collection of images.

McCartney's photography has a poetry and a rhythm but also a sense of reportage, that magical quality of capturing a time, a place and a moment in a single image. He has a talent for taking pictures that never leave you because they often contain more complex messages than is obvious at first glance.

McCartney is not a complete stranger to the area. He mounted an exclusive public exhibition of his Live8 photographs for the award-winning John Lennon Northern Lights Festival at Durness in September 2007 – including portraits of his brother Paul, of Travis and of Annie Lennox. The exhibition attracted worldwide interest. After travelling to Durness to open the exhibition, McCartney was struck by the diversity of the area.

"It left quite a mark and I wanted to return to take part in this big project, but I feel that I've only touched the tip of the iceberg," he said. "I think the North Highlands are unique and there are few more fascinating places. The area has the rare ability to keep drawing people back – including me! In fact the North Highlands were a well-kept Scottish secret ... till now."

Every picture tells a story, but Mike McCartney takes his art one step further. For him, as you will see, every story tells a picture.

CLARENCE HOUSE

My experiences and memories of the North of Scotland go back to my childhood in the 1950s and, in particular, I vividly recall arriving in the Royal Yacht Britannia at Scrabster and the drive all the way along to the Castle of Mey. We continued to do this year after year and the fact that my beloved Grandmother became such an integral part of the richly memorable land and sea-scapes simply intensified my feelings of attachment to this particular part of the world.

In more recent times, I am thrilled to have been able to play a small part in the establishment of The North Highland Initiative. Quite apart from the compelling beauty of the largely unchanged countryside, which is its great attraction, it seems to me that it is vital to ensure that the economic, environmental and cultural life of the North Highlands is developed and improved in a durable, sensitive and empowering way, thus preserving its essential identity.

The images that have been captured by Mike McCartney in this book help to give a wonderful flavour of what is on offer in the North Highlands, and I hope that it inspires many more people to visit and to value this unique part of Scotland.

Billy Connolly

I have been a friend of Mike McCartney for years, decades even. We met in a pub on The Mound in Edinburgh while he was appearing there with his most efficacious ensemble, Scaffold. I was somewhat less than sober at the time, and showed my vast knowledge of showbiz trivia by accusing him of being a member of the group Traffic. In customary fashion he patted my head as you would an old friendly Spaniel and put me right. We have been friends ever since, and a jollier friend no man could ever hope to have.

We became close enough that at one point he invited me to stay the night once at his house in Cheshire, during which I distinctly remember my sox levitating in my bedroom! For more on this you will have to see Mike yourself, although personally I think it had something to do with our closeness to Wales, I'll go no further.

It was around this time that I first became aware of Mike's talent as a snap taker. He showed me wonderful pictures of his young life on Merseyside during all the Rock'n'Roll, Poetry, and Art goings-on, and happenings of which I'm sure you are very well aware. They were not, though, just a collection of famous and not-quite-famous-yet faces, they were always touched by a lovely personal edge that led you to believe that he had a great personal love of the subjects, at least an admiration, but outstandingly lovely and personal. The years rolled by, as years will, and our paths crossed again when he came to see me perform at the great Liverpool Empire, and brought with him his latest book of Liverpool pictures, which I must confess blew me away with their touch which was at once delicate, and at the same time joyous and explosive.

It wasn't until I sat down to write this piece that it dawned on me how much and for how long his pictures have lived in my head. I can see so clearly, without any bother, the mirrored ceiling in the Adelphi hotel foyer. The planes swooping acrobatically in front of the Liver building and over the ships on the Mersey or, my favourite, a mud bespattered picture of George Harrison in a Liverpool gutter.

The Highlands of Scotland pose a particularly unique problem for photographers, in that their spectacular grandeur can become quite wearing after remarkably few exposures. For me, the most powerful aspect of the Highlands is their rather curious melancholy, which can drive the limpest of hands in a poetic direction. This is what I feel Mike can capture; this is what I know he is capable of capturing, and I can't wait to carry them around in my heart.

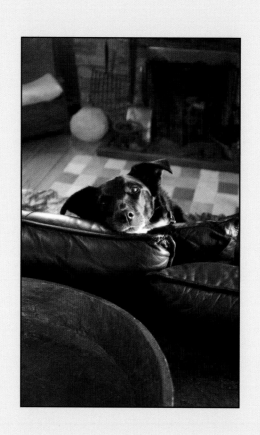

Sir Peter Maxwell Davies

Master of the Queen's Music

It is a great privilege to introduce Mike McCartney on a subject one might think already worn threadbare by too many books.

I am constantly surprised how perception of nature is coloured by impressions received from painting, literature and music.

Think of East Anglia and Constable, the Lake District and Wordsworth, the Malvern Hills and Elgar. With the Scottish Highlands we have a generality of highly Romantic Victorian paintings, maybe the novels of Neil M Gunn, some splendid poetry, but also, alas, a plethora of fair-weather tourist books and brochures, with rose-tinted photographs and fulsome but limp prose.

This new collection of work will make a radical contribution to modifying all that: the photographs are original and unexpected, reflecting their creator's insatiable curiosity and eye for details, leading us deeper into many aspects of Highland life of which we were simply not aware.

It should all be set to music.

MIKE McCARTNEY
PHOTOGRAPHER

photo: Sonny McCartney

and hope you like the fotos too!

17

An Officer and an Albatross

The little dinghy cut its way along the lapping lagoon of Loch A'Chad-Fi on what must be the most unusual school run in Britain.

Steering the outboard was Rebecca Ridgway – the first woman to kayak round Cape Horn; in the bow children Molly and Hughie are due to meet the school bus that will take them the seven miles on to Kinlochbervie primary school.

By boat it takes 25 minutes, but when the weather turns wild the family have a 45-minute walk along a rugged, narrow track around the loch, often in the dark. "Some days in the winter they just don't go to school because the weather is that bad, so we do home education … but I think they are getting an upbringing few other children experience," said Rebecca.

The Ridgways live on the Ardmore peninsula, 15 miles south of Cape Wrath. Rebecca's father is John Ridgway – Atlantic rower and three-time round-the-world yachtsman – whose converted croft perches on a hill at the end of the loch. He and his wife Marie Christine founded an adventure school now called Cape Adventure International, presently run by Rebecca and her family.

It was back in 1966 that the then Captain Ridgway, of the Parachute Regiment, took just 92 days to row the North Atlantic with Chay Blyth. Their 20-foot open dory was called English Rose III; his round-the-world yachts, English Rose IV and VI, are all now moored on the loch below.

Now 70, former boxing champion and ex-SAS, John has the physique of a man half his age and has devoted much of his later life to saving the widest winged bird on the planet … the Albatross. In 2003 he and his wife set off around the world for the third time to highlight the bird's plight – around 100,000 Albatrosses die each year on fishing hooks – and stopped off in Rome to present their 105,000-signature Save the Albatross petition to the UN.

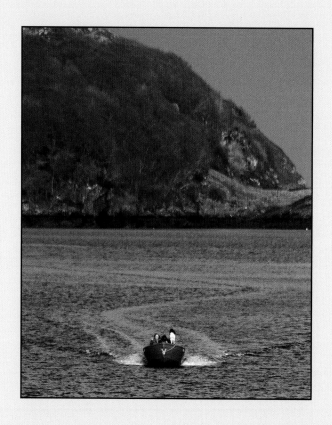

Right. After half an hour on the ocean waves, Molly and Hughie are happy to give huge land-locked smiles to my Nikon D200 camera, before they step into their school bus.

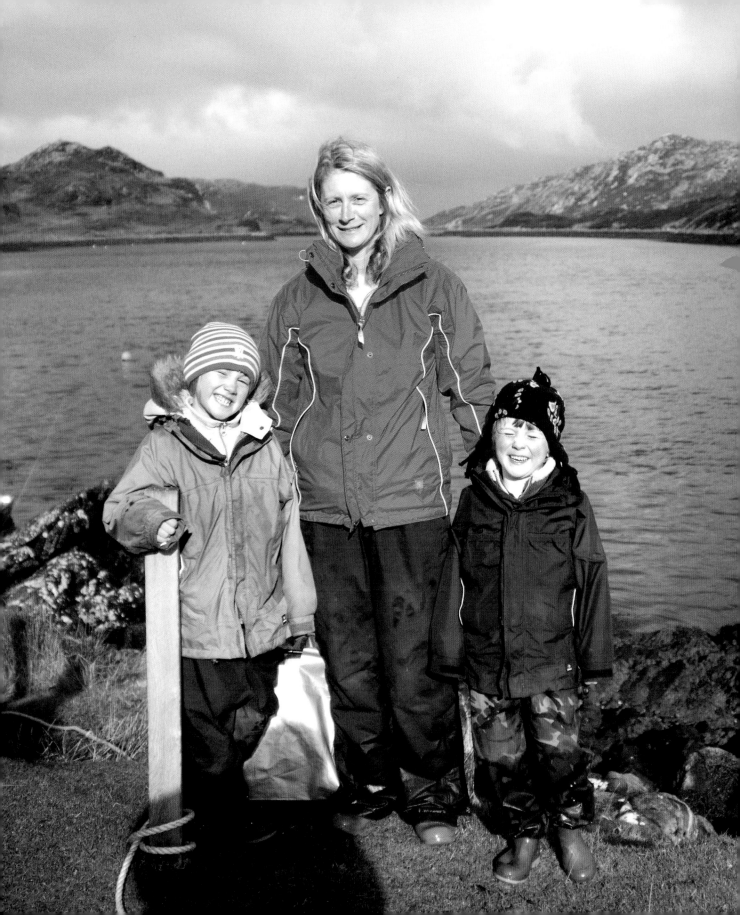

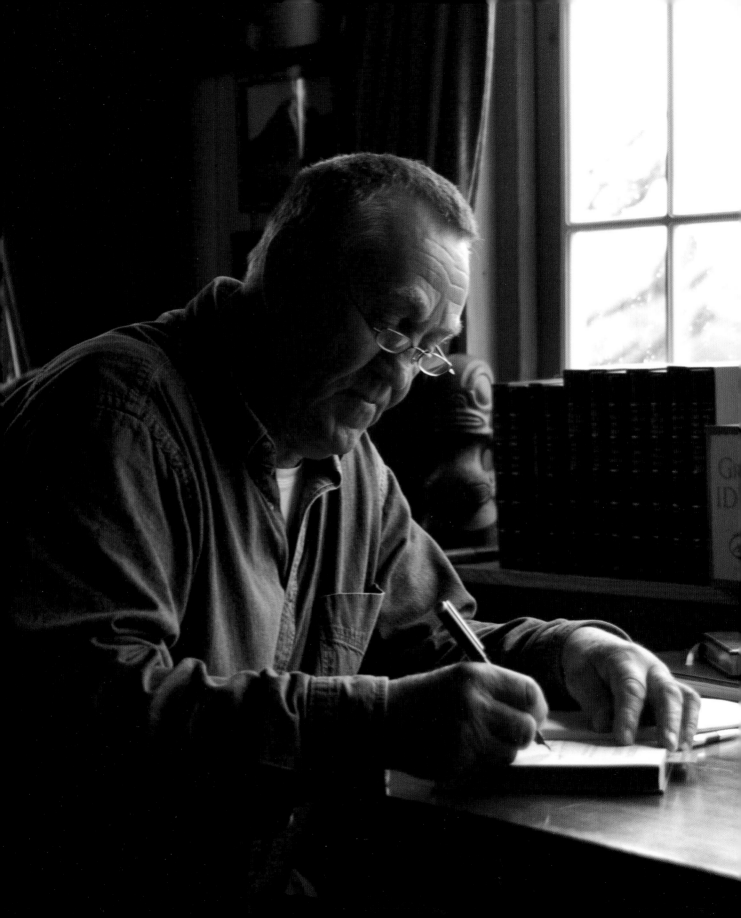

Captain John perusing a photograph of his Third BN the Parachute Regiment, which includes Sergeant Chay Blyth. They both feature in a great Peter Nichols book 'A Voyage for Madmen' (nine men set out to race each other round the world … only one made it back!).

JR's Autograph

Left. Given the great honour of visiting round the world yachtsman and rower John Ridgway in his remote highland hideaway, this is the great man signing a first edition of his 'Fighting Chance' novel for my Hi!-lands mentor, Mike Merritt (another MM!).

Albatross View

This is the breathtaking view John Ridgway has every time he climbs up to his den ... including some of his Armada, below. Having sailed, and rowed, round the world so often, John now feels it's time to relax. "I've taken myself out of public life this year," he said. "In fact you're the only one in my 2008 diary." "I'm honoured" I replied, "but what are you going to do now?" "Be an albatross" answered John, without batting a feathered eyelid.

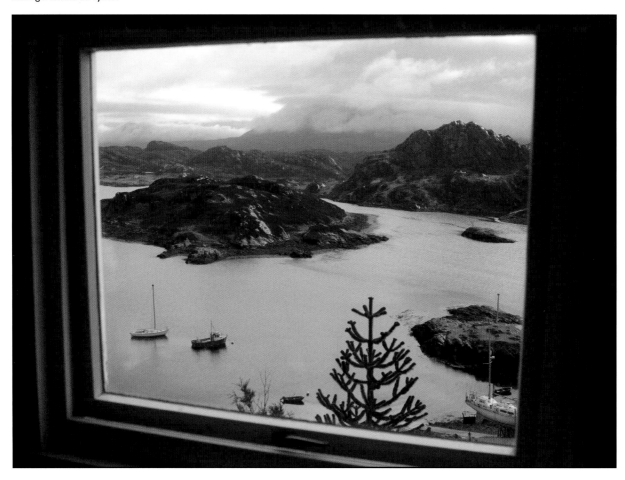

Right. Resting silently in a shed next to his daughter's 'School of Adventure' kayak, John gazes at the 20-foot open boat he and Chay Blyth rowed across the Atlantic during 1966 (the year I wrote 'Thank U Very Much'! for Scaffold).

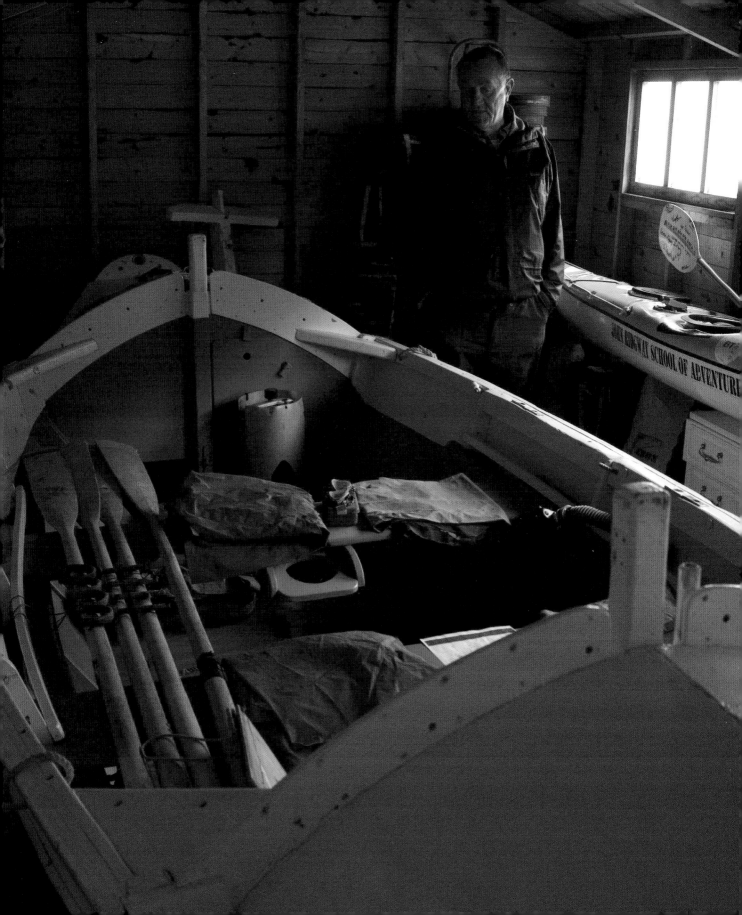

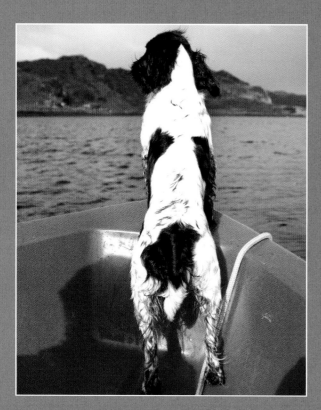

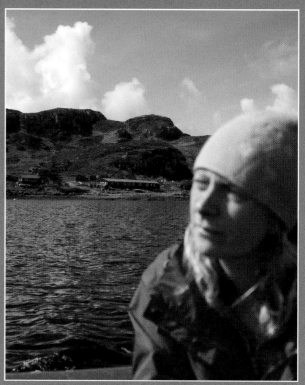

The Ridgways' trusty dog Poppy … or should I say
Captain Poppy … who commandeers the boat as we
chug down the loch.

A thoughtful Rebecca, with a background of the
Ridgways' Adventure School on the banks of the
loch.

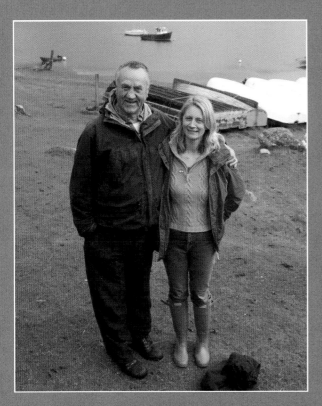

Dad and daughter. After several hours of yarn swapping with former boxing champion John, I finally got this lovely smile … with daughter Becca.

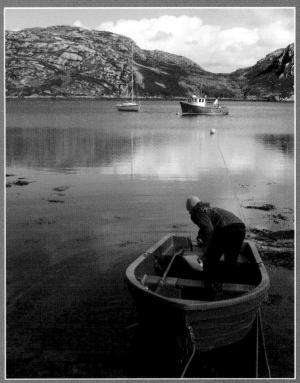

I was thankful it wasn't a kayak! as Rebecca readied our boat for the return trip. One of John's famous boats nestles in the bay.

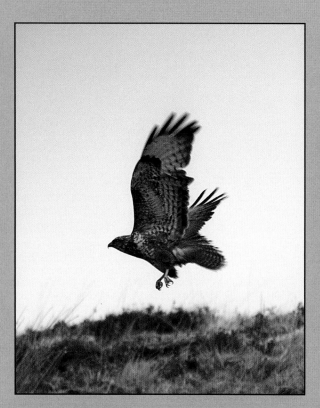

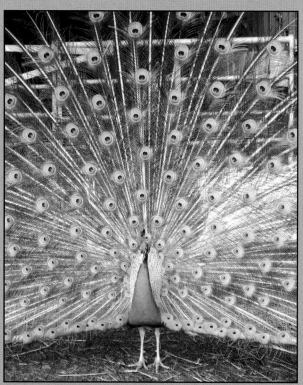

Two examples of the surprises you constantly encounter in the North Highlands ... a low flying Buzzard and a glorious coloured Peacock.

Right. You'll hear about spiteful castles later, but high up in the Highlands I found this ruined castle actually *looking* at me.

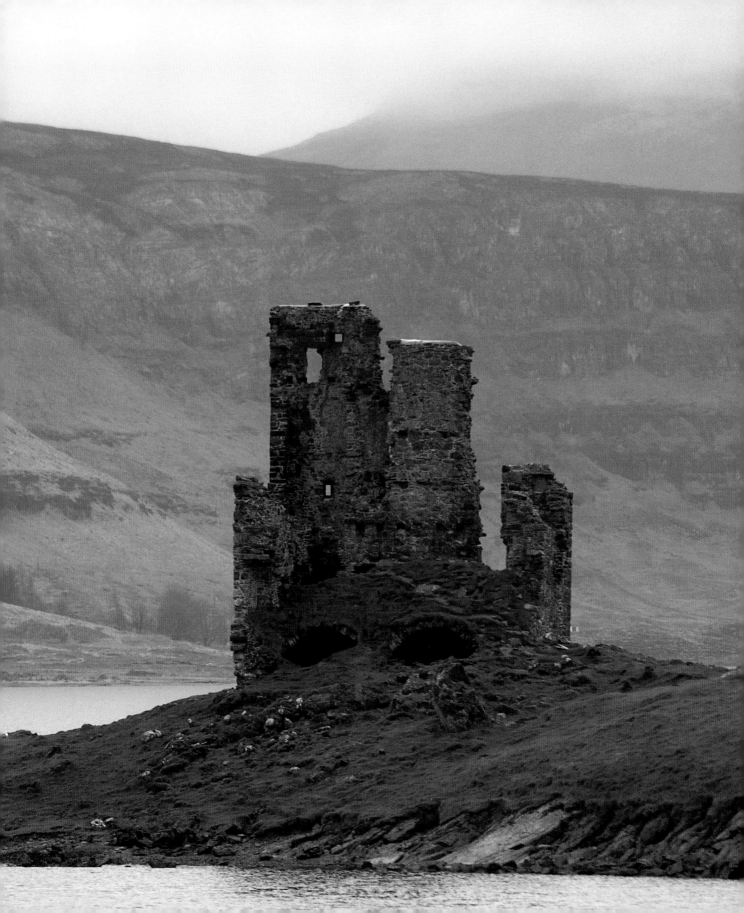

Highland Sand Bank

Taken on the picturesque Sutherland coastal route to Tongue, past the Mouth of the river Navel and Kin-Lick-Bevie, nosewhere near the Foot of Kintyre or Shin Falls, this North Highland sand bank is the safest bank in Scotland!

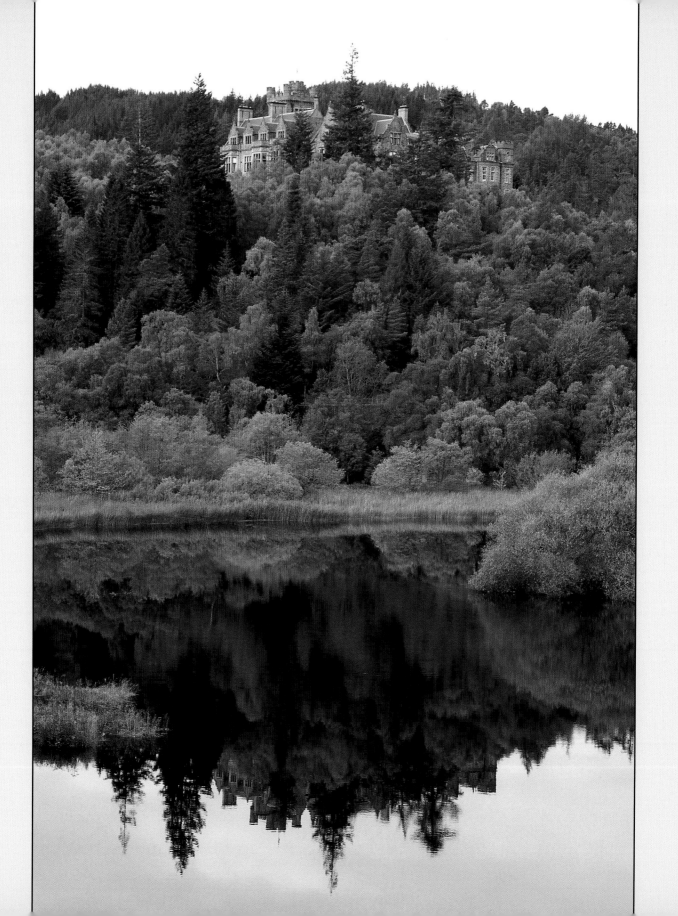

PC Pose

We flagged down PC Ian Sutherland in the middle of nowhere, as he has the distinction of having the biggest beat in Europe ... 900 square miles! Not only that, he has no police cell ... to lock up any unruly sheep.

Castle Spite

Left. This is Carbisdale Castle or 'Castle Spite', former home of Mary, Duchess of Sutherland. In 1892 she was imprisoned in London over the will of her late husband, the Duke. A settlement with the Duke's family was finally reached, as long as the Duchess built her castle *outside* the Sutherland Estate. To spite her former relations Mary built her castle overlooking Sutherland right on the banks of this river, along which the Sutherland family had to travel south by rail. On their return, the furious Sutherlands would draw the carriage blinds as they passed Castle 'Spite'. In return, Mary built an eight-sided, silk-lined opium room in her castle, plus a three-faced clock tower, with a *blank* side facing the Sutherlands, as she had no time for her ex-relations.

Typical highland weather. In the morning, cold and belting down … and (*right*) in the afternoon hot and sweating … particularly if you're this young lady cycling your 'Adams' bike up steep highland hills on the east side of Loch Eriboll.

John's Secret Hideaway

Few places can be as spectacularly positioned as Durness, the most north-westerly inhabited place on mainland Britain.

With its dramatic cliffs and stunning sweep of white-gold sandy beaches this is one of Britain's hidden gems. It is also where the 9 to 15-year-old John Lennon spent happy summers on his cousins' croft. The area is said to have part inspired the song 'In My Life' and, in 1969, Lennon returned with Yoko Ono and children Julian and Kyoko, unfortunately ending up in hospital after a car, driven by John, crashed on the Kyle of Tongue. John was reportedly interested in buying the Durness estate before his tragic death in 1980 and the village now has a memorial garden dedicated to him.

The area contains the largest bombing range in Europe, and the only one on the continent where 1,000-lb bombs can be dropped. During World War II service personnel stationed here nicknamed Loch Eriboll, 'Loch 'orrible' because of the often harsh weather; the company of HMS Hood spent their last shore leave before the fateful Battle of Denmark Strait; and, in May 1945, the German U-boat fleet surrendered in the loch.

It is very different today. An old RAF camp now houses a craft village, including Paul Maden and James Findlay's chocolate factory and a bookshop owned by Simon Long and Kevin Crowe, the first gay couple in the Highlands to marry in a civil ceremony. And there is a very different kind of fleet: a remarkable set of floating stones and sculptures on the croft of Danish-born ceramic artist Lotte Glob creates a surreal, elemental landscape before the majestic Ben Hope.

See the ruined and roofless Durness Old Church, where skull-and-crossbones mark the tomb of highwayman Donald MacMhurchaidh, who murdered 18 people but funded the church generously in return for a burial.

Nearby a nine-hole golf course is also a nature reserve and a 600-metre tidal gorge leads to Smoo Cave, Britain's largest entranced sea cave. Then just 11 miles away is Cape Wrath, where the — now unmanned — lighthouse was built by Robert Stephenson in 1828. It also now has the remotest café in Britain, run by John Ure.

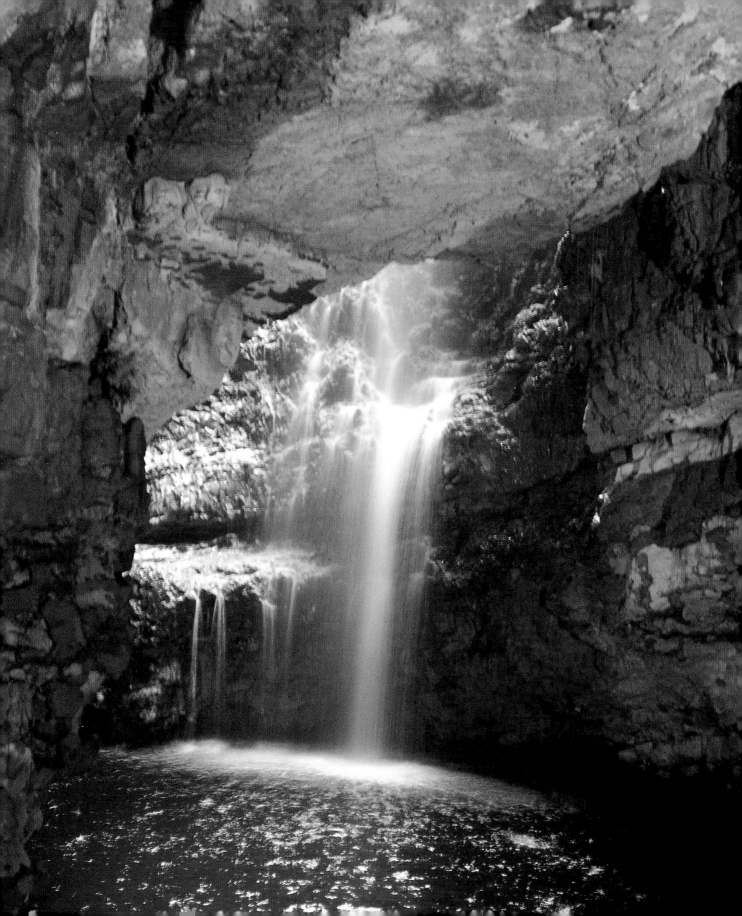

I was asked why I thought this photo was so unusual. I answered "In England you don't get many black cows on pink beaches eating the sand!" In the background is the military controlled Faraid Head, eleven miles from the biblically named Cape Wrath. PS They eventually whispered that the coos were eating seaweed.

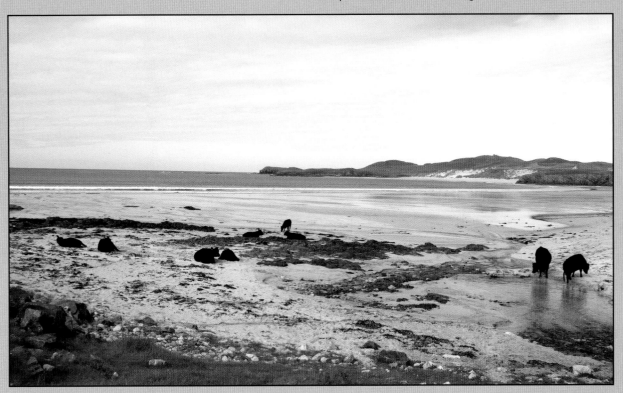

Left. Inside Smoo Cave, Britain's largest entranced cave.

The troops can't see Garvie Island from here so they fire low over the hill to their target below. Woe betide any sheep that grazes by or it'll be roast lamb in the canteen tomorrow!

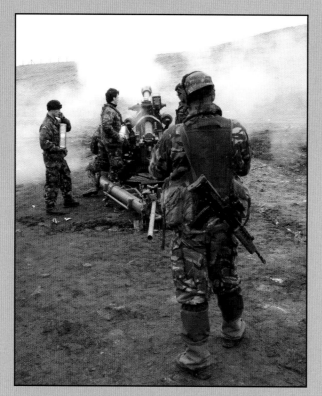

C Shells by the C Shore

Right. On the outskirts of Durness, these shells from artillery howitzers had been used for gun range practice on Garvie Island Rock, off the pink beach of Durness. They made a nice copper composition.

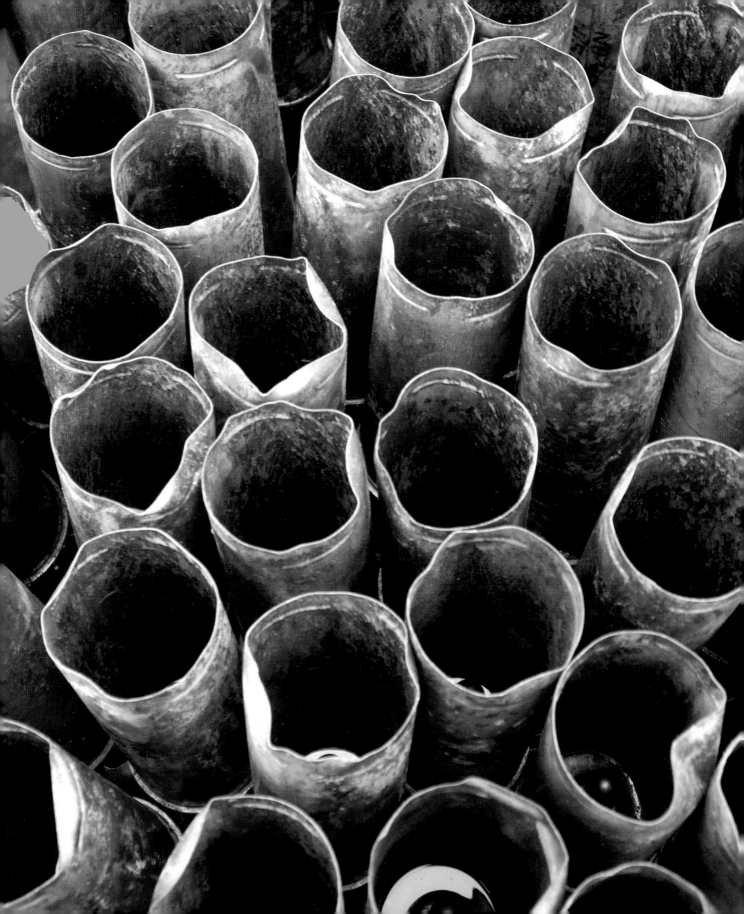

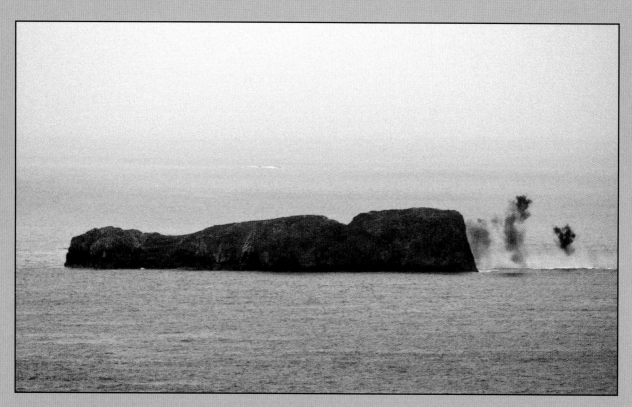

It's all quiet on the (North) Western Front, till the army, navy and airforce bomb the hell out of this innocent little (Garvie Island) rock.

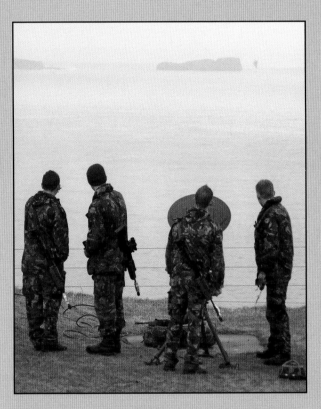

Machine guns slung on their backs like tennis racquets,
four young squaddies watch an artillery 'near miss' on
Garvie Island from Farraid Head cliff edge.

A mickey-taking 'V for Victory' salute from this young
soldier, just before he was posted to Iraq.

Laid out to rest on the floor of their 'Cocoa Mountain' factory, methinks
Paul Maden and James Findlay have had a trifle too many truffles ...
they think they're in a François Truffle film!

Left. Just before they overdosed on truffles, I asked Paul and James
to walk through their golden chains, hung to keep midges off their
delicious chocolates. This was the result ... one day we'll get to see
what they actually look like!

Lady Loom

If she hasn't been knighted yet, young Noel Bose certainly should be ...
for her service to patience. Here she is, gently weaving in her Durness
craft cottage.

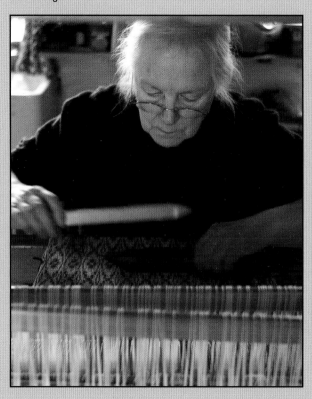

Scottish Fiction

Left. Not so much fiction, actually all fact. Kevin Crowe and Simon
Long run the remotest, cosiest bookshop in Britain, and were the first
couple to have a civil partnership in the Highlands.

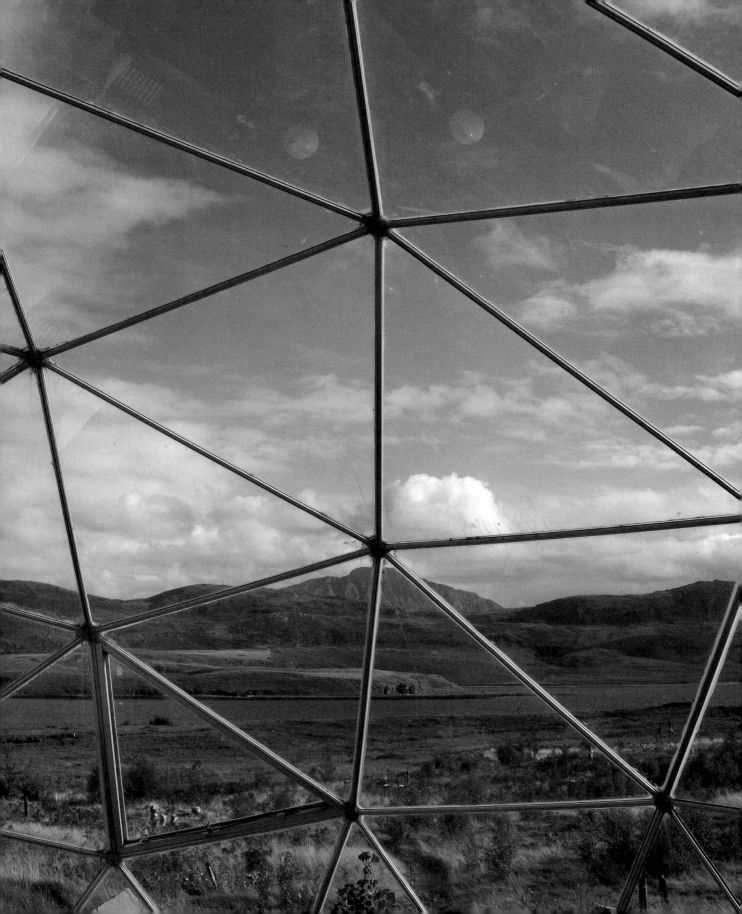

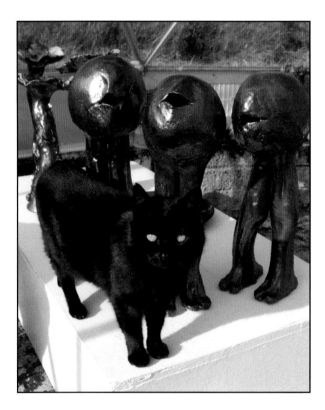

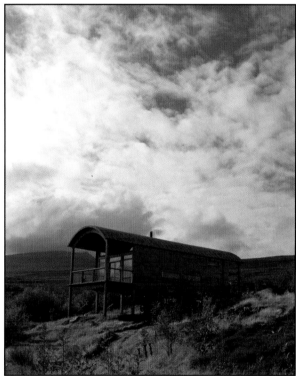

Glob's Glass Hoose

Left and above. In the grounds of Danish sculptor Lotte Glob's home, are many exotic artefacts and surreal ceramics. Overlooked by Ben Hope mountain, this glass house, full of unusual sculptures and friendly black cat, is just one of them.

The Triptych

Chatting away in Lotte Glob's magnificent home on stilts near the outskirts of Durness (*previous page*) – and completely unknown to Lotte, Mike and Marion – I noticed that if I placed my camera at a certain angle to Lotte's lamp, the fab three would all be wearing Vietnamese pottery hats. Let's hope they still talk to me when they see my triptych!

After running to be early for bible studies on Thursdays, minister John Macpherson posted this note to his obviously very hot highland parishioners.

CHURCH OF SCOTLAND

**EDDRACHILLIS
PARISH CHURCH**

WORSHIP AND
SUNDAY SCHOOL . . . 12NOON

BIBLE STUDY AND
PRAYER . . THURSDAY 7.30P.M.

MINISTER
REV. JOHN MACPHERSON.
ALL VISITORS ARE WELCOME.

**THIS CHURCH
IS PRAYER
CONDITIONED**

INSIDE AND OUTSIDE A GOLF BALL CALLED FRED

In an area bulging with castles there is one that few get to visit. The 16th century Dounreay Castle has few tourists and its position explains why ... to reach it you must travel through the grounds of the former Dounreay Nuclear Power Development Establishment.

Dounreay once led the world in nuclear research and is still dominated by the iconic 'golf ball' that housed Britain's experimental breeder reactor FRED (Fast Reactor Experiment Dounreay), bizarrely during the construction of the 41-metre diameter dome, the world record for welly boot throwing was set.

By 1994 the three civil nuclear reactors had ceased to operate, with the last nuclear fuel element manufactured in 2004. Now 2,000 workers are engaged in the £2.7 billion task of decommissioning Dounreay's 135 acres and returning them to a greenfield site – due for completion in 2025.

A strange community grew around Dounreay. The bank, a shop and a large police station remain, even a burger van is positioned between two nuclear reactors – almost like a post-apocalyptic scene from Mad Max! Once there was also a hairdresser, a dentist, golf putting green and soccer pitches. Prior to 9/11 visitors were even taken on a bus tour of the complex!

There were social consequences to the construction of this nuclear community: nearby Thurso trebled in size to some 9,000 people within a decade and one-fifth of jobs here still depend on Dounreay. The huge influx of boffins and their children meant that, in the 1960s and 70s, Thurso had the highest proportion of graduates per head of population outside of Oxford and Cambridge.

Historic Scotland is now looking at ways to preserve the iconic golf ball squatting on the edge of the Pentland Firth as a monument to Britain's industrial heritage. The future may lie in the Firth. Experts say tidal power could generate the same electricity as a nuclear power station. First the atom, now the sea – this part of the North Highlands still plays a vital part in the nation's energy needs.

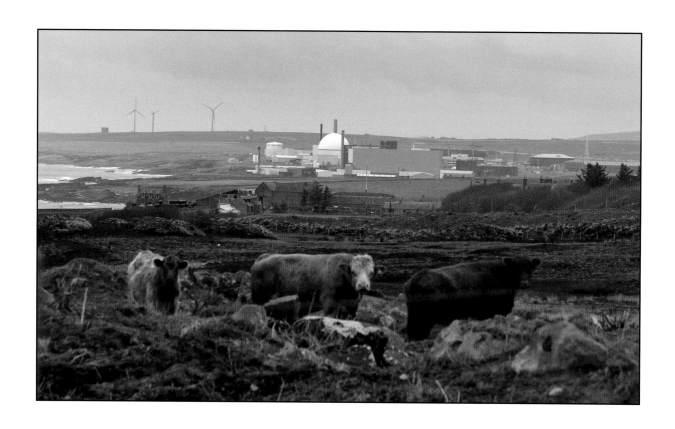

In a low-lying bay of the Pentland Firth, the enormous Dounreay 'Golf Ball' dominates the surrounding scenery, so the fun was placing the ball in as many different positions as possible.

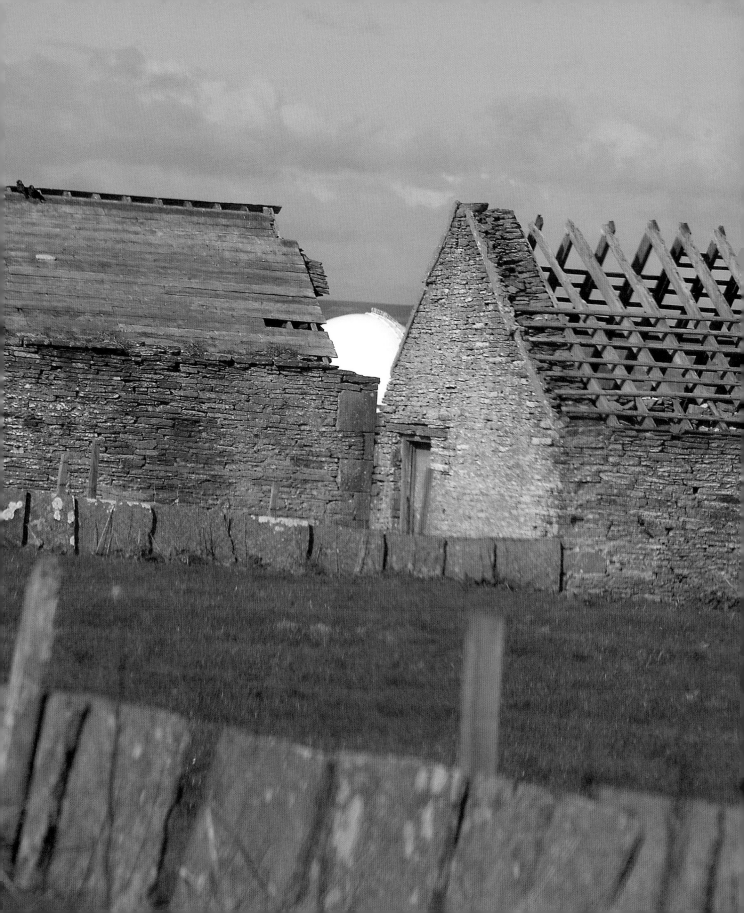

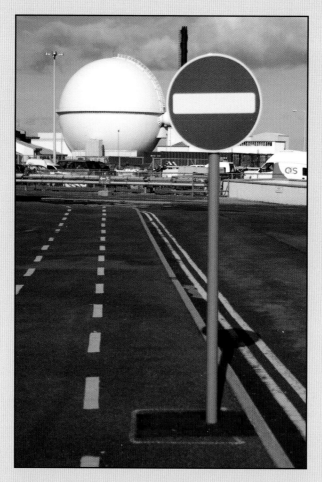

No Entry Balls

On entrance to the Dounreay nuclear plant, the roundness of the
no entry sign and the roundness of the Dounreay 'golf ball' was too
tempting to resist. Taken just after I was nearly arrested (for taking
photos) by the security policeman, from … Liverpool!

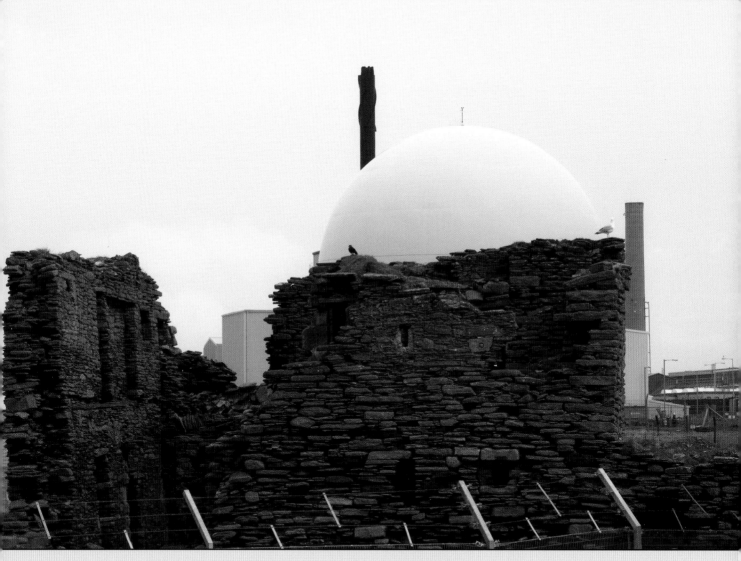

Dounreay Egg

How those tiny birds managed to lay that giant egg in Dounreay Castle,
I'll never know!

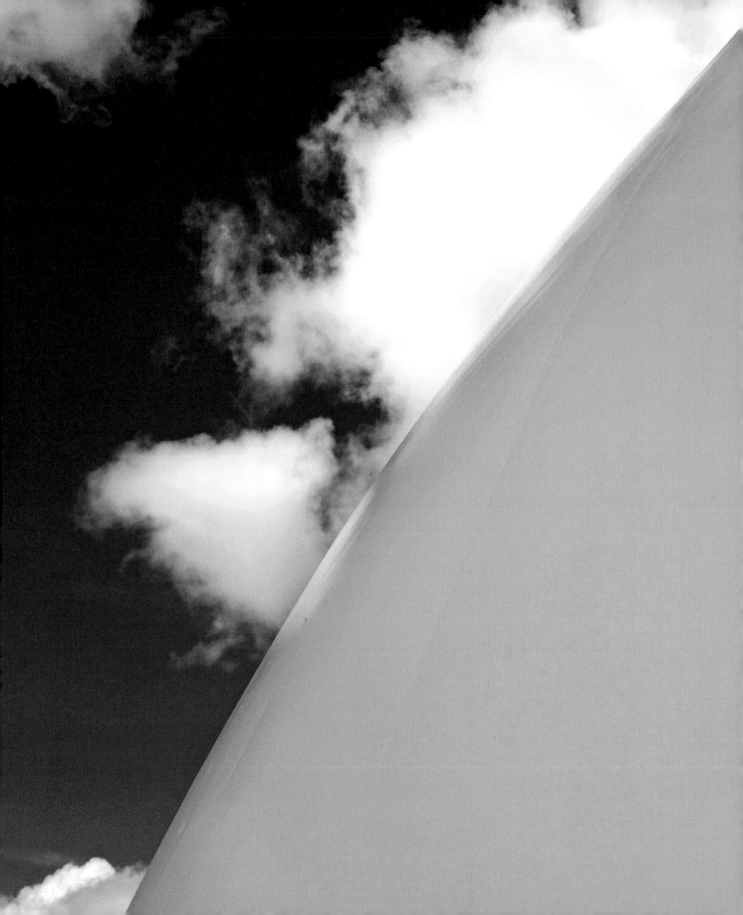

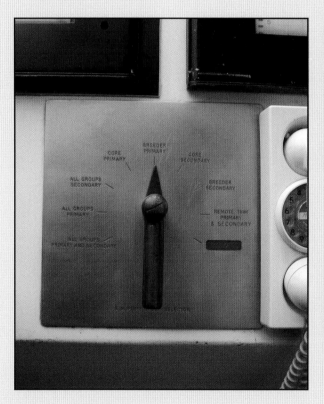

'NUKEM'

… an appropriate title for a nuclear facility firm (or is the boss from Liverpool too?).

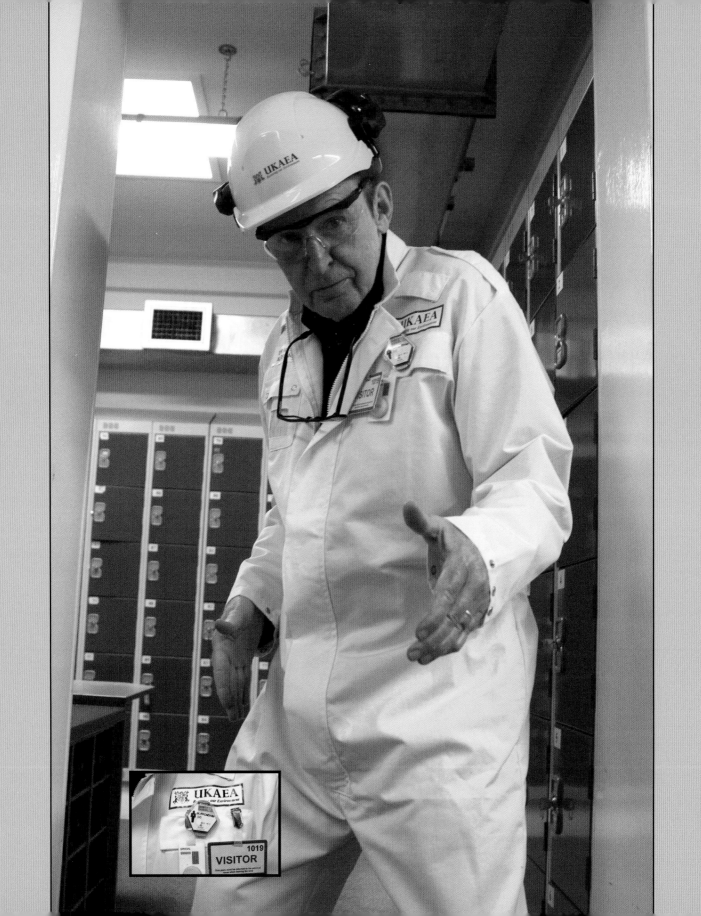

These lads had to don the full decontamination suits and masks to enter the inner sanctum of the Golf Ball, but one saw my camera and managed to play his 'squeeze box' for me ... my personal Nuclear Rod (Stewart).

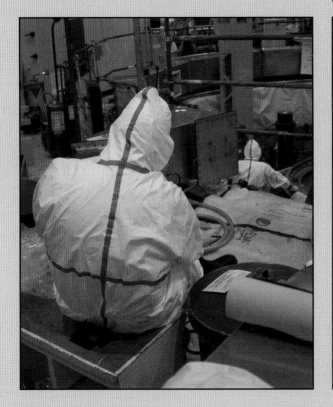

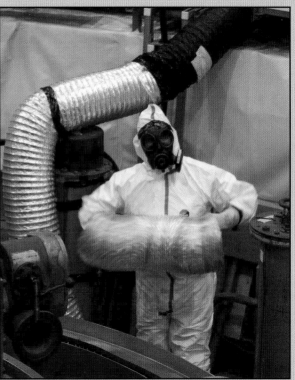

Left. 'Mike McVisitor 1019' gets inside 'Nukem' Dounreay and is attempting an Elvis pose before they fry him to a frazzle. Luckily they take contamination seriously at Dounreay ... hence all the protective gear.

As I say, Dounreay takes contamination very seriously, and I must admit it was very reassuring to be given the 'all clear' at the end of my visit.

Right. Grazing in a field in close proximity to the Dounreay Nuclear Site, the rumour that these are Dounreay sheep is totally unfounded (I just couldn't resist the joke).

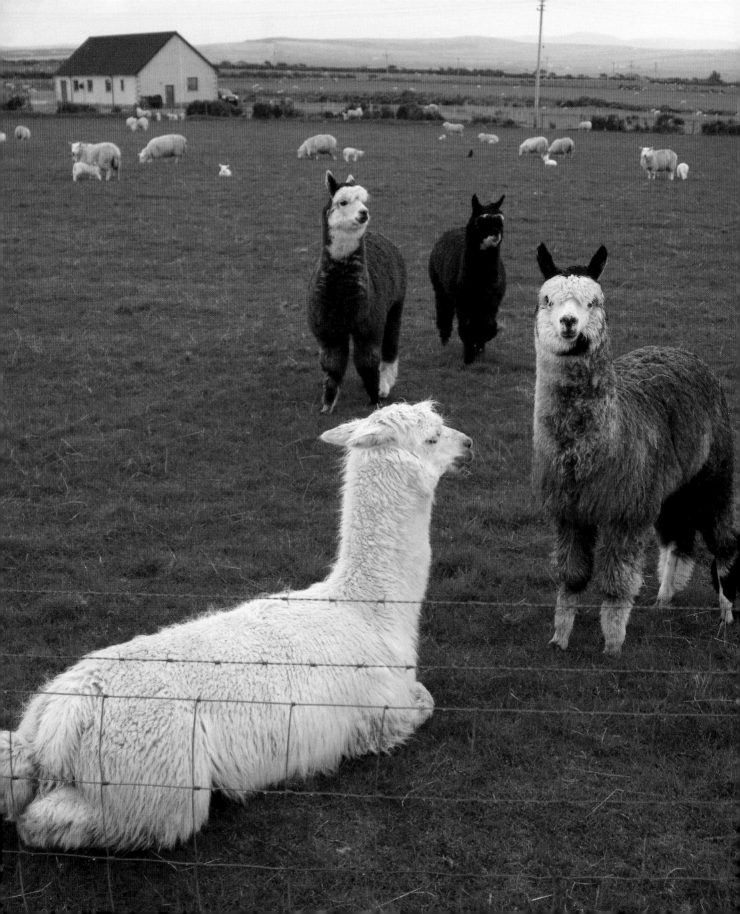

A young noblewoman waiting to be beheaded makes her escape from Thurso Castle by … surf board.

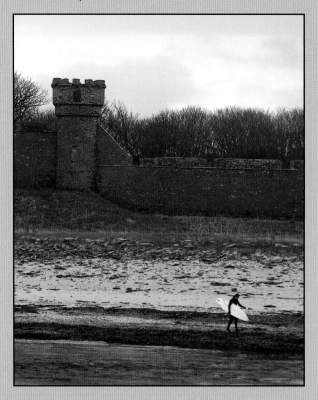

Right. Taken in Thurso's surfing shop window, a self-portrait in the rain. Surfing weather … Highlands style! At least you get wet before you get in the water.

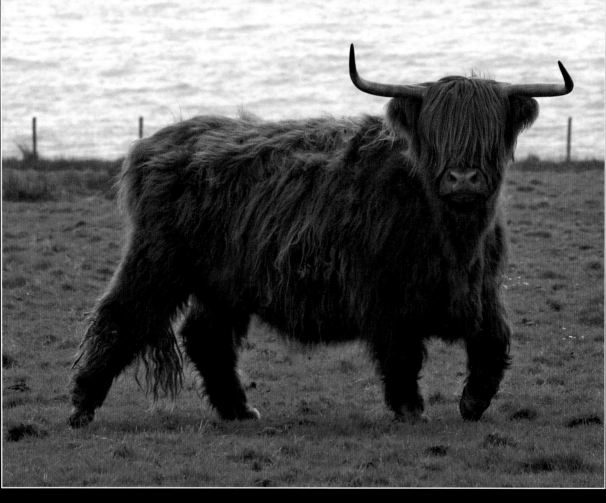

"Are you looking at me Jimmy?"

Mey the Force Go With You and Think Pink

The Castle of Mey was the only home the late Queen Mother owned.

In 1952, in mourning for her husband, King George VI, she first saw what was then Barrogill Castle. On hearing it was to be abandoned, she exclaimed: "Never! It's part of Scotland's heritage. I'll save it." And she did – also restoring the ancient name, Castle of Mey.

In 1996 it was handed over to a charitable trust and every August Prince Charles spends a week at the castle. He even has his own whisky with a self-designed label – Barrogill – made by local distillers Inver House, who have strong links to nearby Wick, known as a silver and gold town for the 'silver darlings' of herring and its golden dram.

Wick caught the eye of LS Lowry who, in 1937, produced 'Old House Wick' and 'The Steps, Wick', still much the same as when Lowry painted them. Wick boasts the shortest street in the world: Ebenezer Place, it fronts Mackays Hotel, measures just 6ft 9ins and Robert Louis Stevenson, who spent some of his childhood there, referred to it in 'Treasure Island'. The town has also moved with the times with the most eco-friendly Tesco in the country.

Thirty miles down the A9 the village of Helmsdale became the site of the start of the Scottish Gold Rush in 1869, sparked when a local man, Robert Gilchrist, found a 10 pennyweight nugget: The Scottish Parliament Mace contains an embedded ring of Scottish gold. People still pan for gold around the Kildonan Burn.

Helmsdale, however, has more of a pink hue. The La Mirage restaurant was created by the late Nancy Sinclair, a Vogue model who had been born with spina bifida. Nancy died in 2007, aged 75, but her son Don keeps his mum's nearby house as a pink shrine to her larger-than-life personality. He showed us around and we needed sunglasses to dim the pink glare!

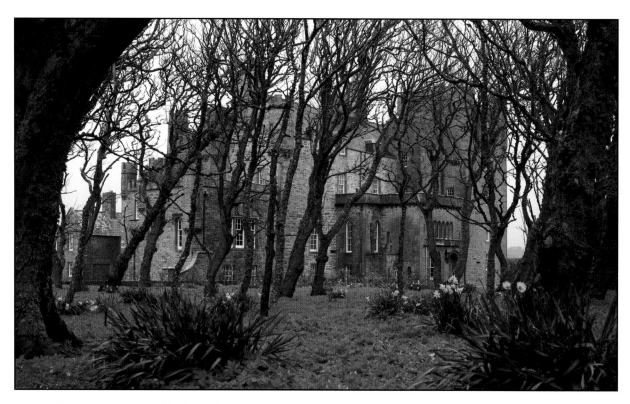

Thank U Very Much for the Castle of Mey

I visited the Queen Mum's old Castle of Mey home on a cold, rain-soaked day, so outwardly it seemed a little sombre and cold but inwardly it has a warm, homely, family feel to it ... particularly when the Major shows you around.

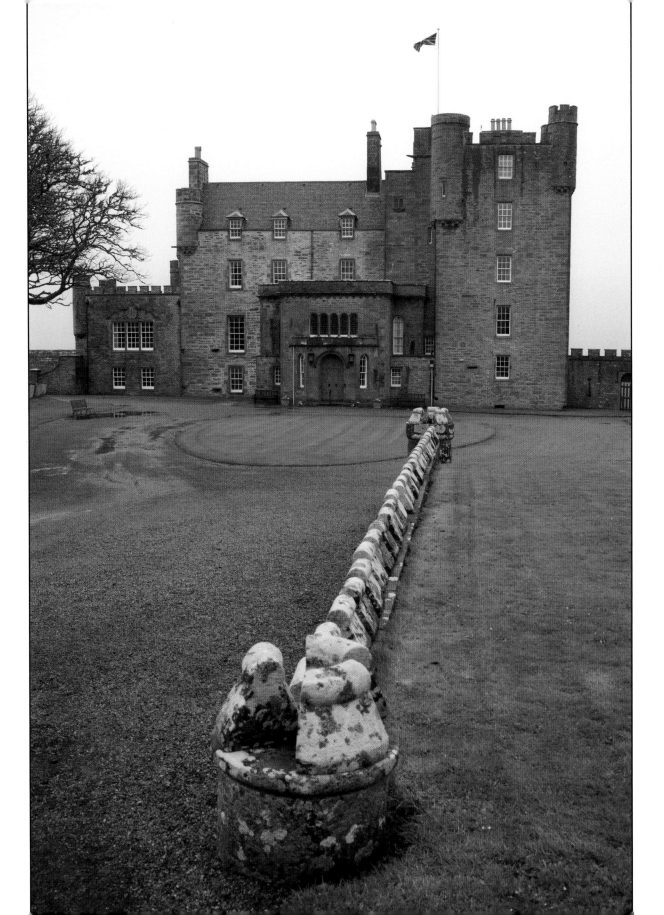

The 'Singalong' Dining Room

Left. Close-up of above. I think this is a Prince Philip painting.

On walkabout, old loyal friend of the Queen Mum, Major Johnnie informed me that her favourite song was my 'Thank U Very Much' Scaffold ditty! After dinner, during singalong with her daughters, Her Majesty would insist on going solo for the 'Thank U Very Much … for our gracious Queen' words at the climax of our top 5 record. I didn't have the heart to tell the Majors that the *actual* words of my song were … 'Thank U Very Much for our gracious TEAM' (ie Liverpool FC!).

The Queen Mum and daughters make the cover of the first edition of the Spanish magazine 'Hola' … better known here as 'Hello'.

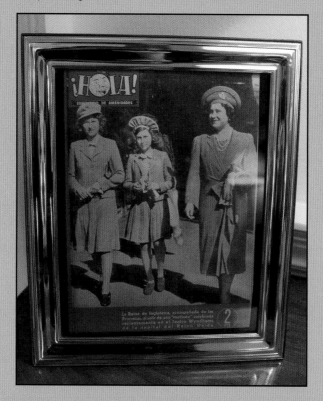

Right. The strange coincidence of two working class lads listening to a Peter Sellers' album in their two-up, two-down Liverpool council home, and the Queen Mother and family listening to the same 'Songs for Swingin' Sellers' LP in their slightly larger castle! The producer of this Goons' record was George Martin, who brother Paul chose as the Beatles' producer and then the Scaffold chose, not for his rock and roll prowess, but for his comedic expertise.

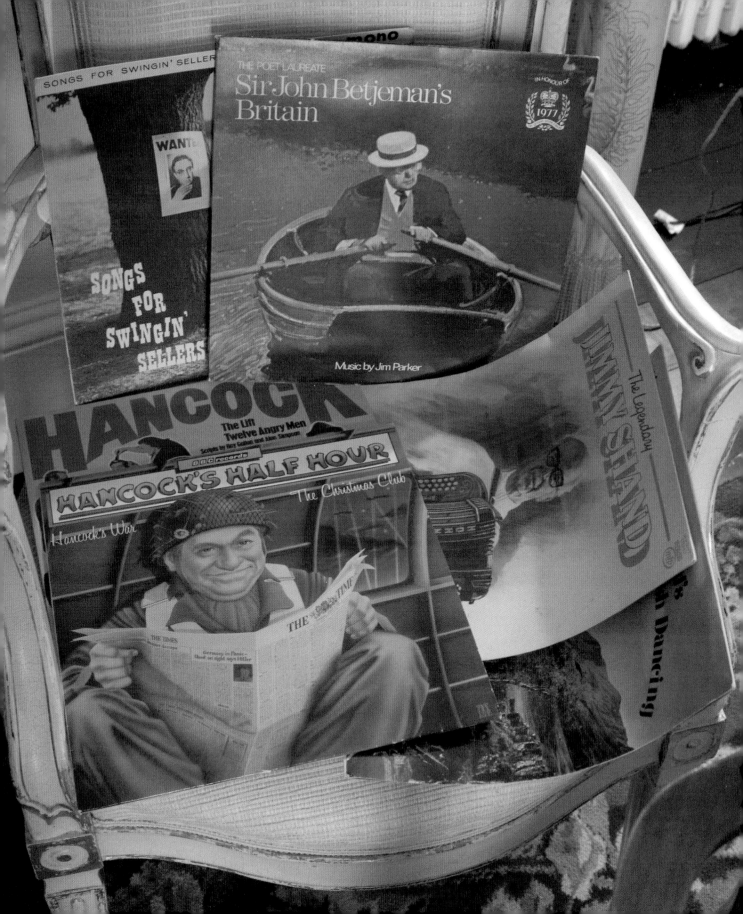

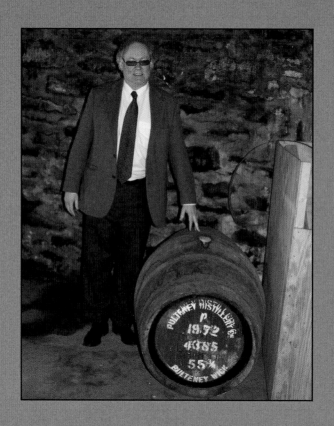

Right. When Prince Charles visited Wick and the Old Pulteney Distillery in 2005 they casked this favourite tipple in his honour. Having lived in Wick a little longer, Murray Lamont (*above*) has a cask from 1972, ie 36 years old! Strangely nobody has asked me if I'd like a cask ... yet. They might have heard I like Coke with my scotch ... NOT a good drink to order in a Scottish pub!

Copper Whisky

Before the Old Pulteney whisky is poured into the Old Pulteney cask and left for many years to become OLD, it is distilled in giant copper stills (in fact … *dis* still) which make great shapes to photograph.

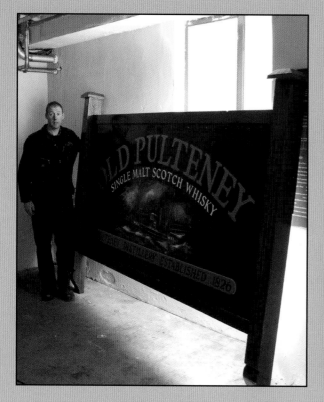

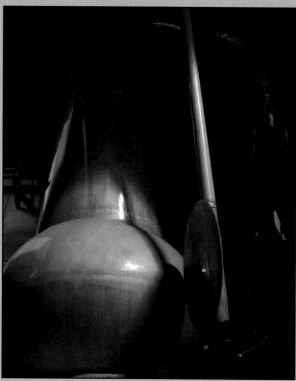

Rght. This 'Gunfight at the OK Corral' … took place at the Old Pulteney whisky distillery in their Wick warehouse … so I call it 'Gunfight at the OK Barrel'. If you don't believe me, check it out in Wickipedia.

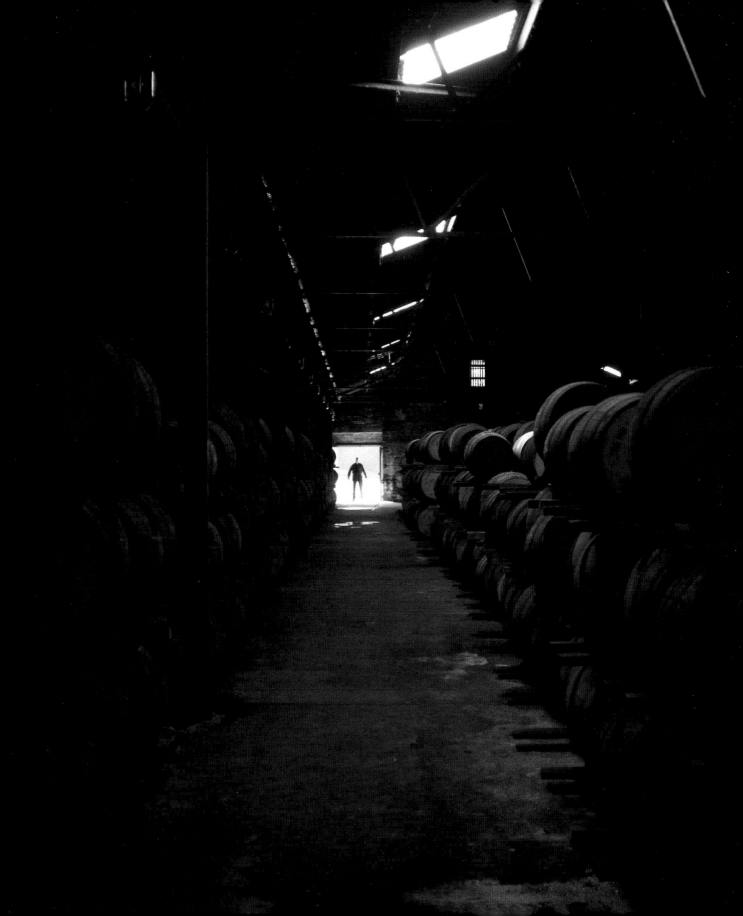

After L S Lowry and his Aunt visited the area in 1936, matchstick men, women and kids, eventually made it to Wick ... Wicked!

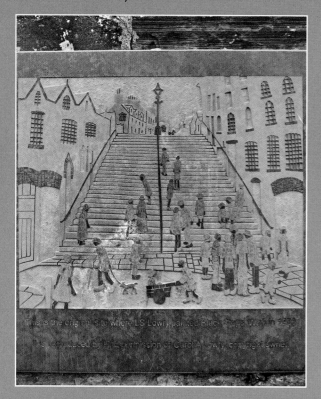

Number 1 Ebenezer Place

Right. After the longest beat (in Europe) ... the shortest street (in the world!). At the end of Mackays Hotel in Wick, I persuaded the unsuspecting Wickers to walk round and round ... and round! the six foot nine inch length of Ebenezer Place, to simulate a normal street. They kindly, and unbelievably, acquiesced.

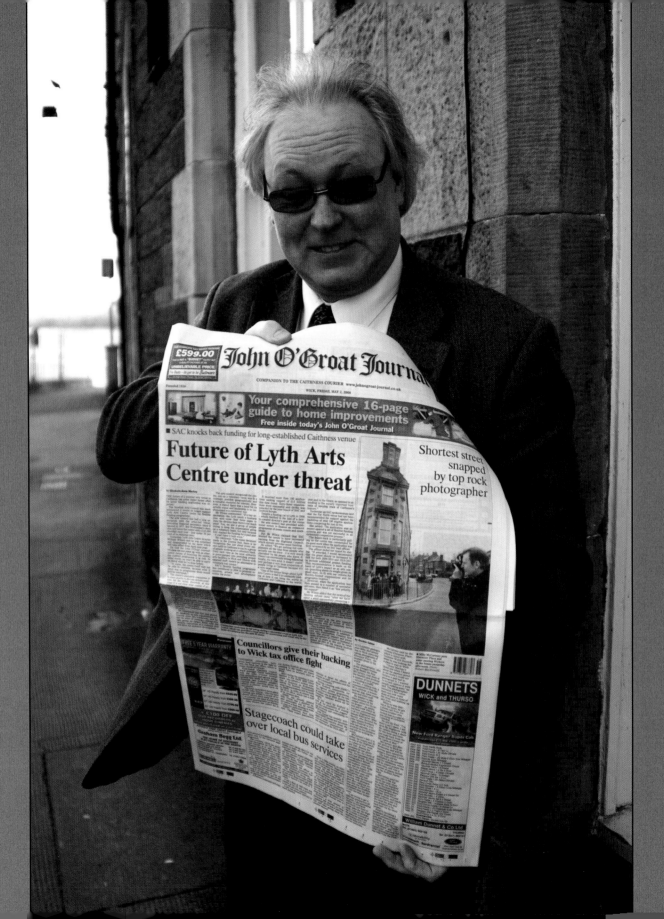

Not that whisky is important in this part of the world, but who needs petrol when you can fill up with Old Pulteney single malt?

Left. Murray Lamont, the softly spoken, friendly boss of Wick's 'Mackays Hotel' (and Wick?!) holding the local John O'Groat Journal with 'top rock photographer' me, on the front page … fame indeed!

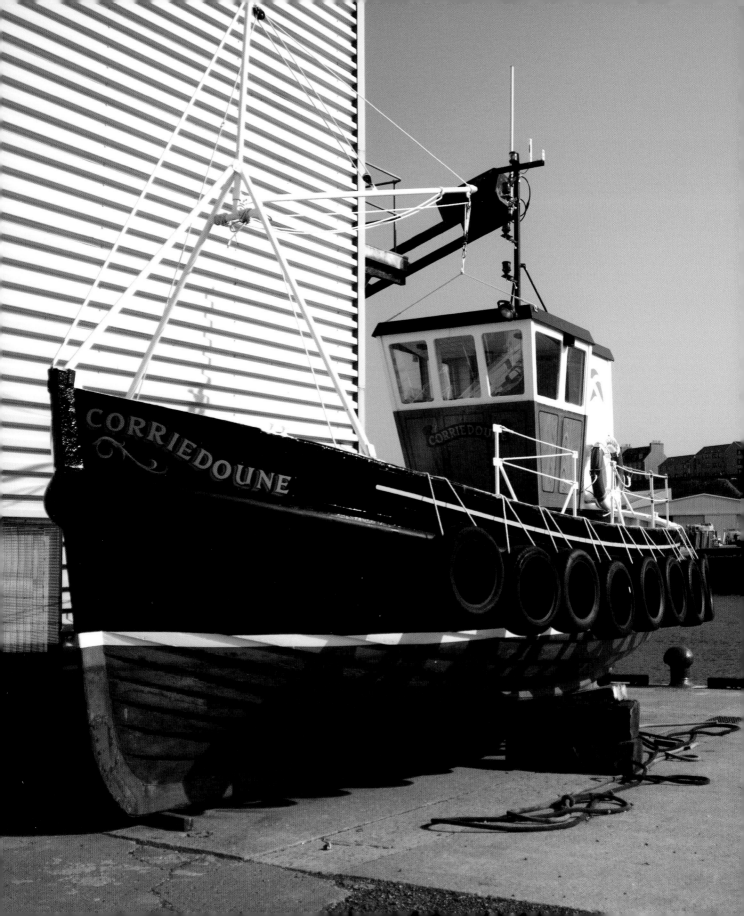

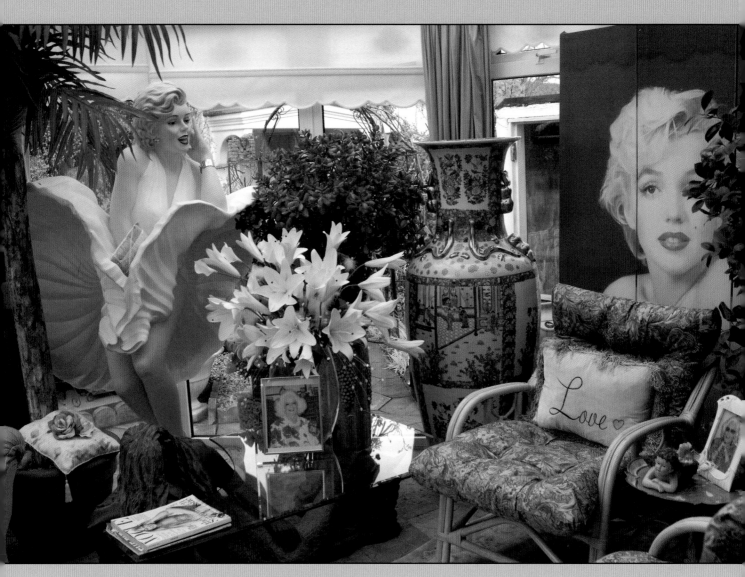

Lily the Pink's Highland House: home of Barbara Cartland fan and ex-Vogue model Nancy Sinclair, and kept as a pink shrine to his mum, Barbara and Marilyn Monroe! by son Don. Nancy even went out in style … in a pink coffin!

The Golden Rules …

A must-read before gold panning around the Kildonan Burn, near Helmsdale, eg Rule No 9: 'If rocks can't be moved with bare hands, they should not be moved etc.'

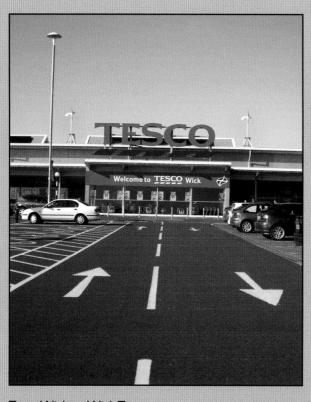

Tesco Wick … Wick Tesco

The most eco-friendly store in the country, with a 50% smaller carbon footprint than conventional supermarkets of similar size … let's hope Liverpool lad Terry (Tesco) Leahy had a say in that.

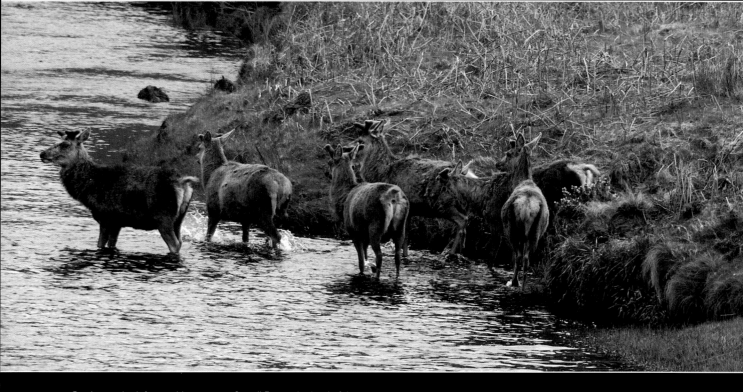

On the way back from gold panning on Suisgill Estate, this herd of deer saw that I was watching them and took the unprecedented step of all taking to the river … or this is where they take a daily bath!

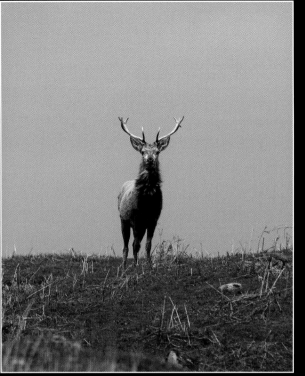

Stag Stare … On the long riverside road to Suisgill Estate to have a go at gold panning, we spotted a herd of deer led by this curious young buck. He was relieved that I was shooting on my Nikon D200 camera, rather than a high-powered, telescopic rifle.

Having just shot a healthy young stag, I couldn't resist this sign just down the river … neither could the frustrated huntsman!
Dear Oh Deer!

Having visited Lands End in Cornwall at the bottom of Britain, it was only right to travel up the 874 miles to drop into John O'Groats at the top. Note: Liverpool … only 503! Miles.

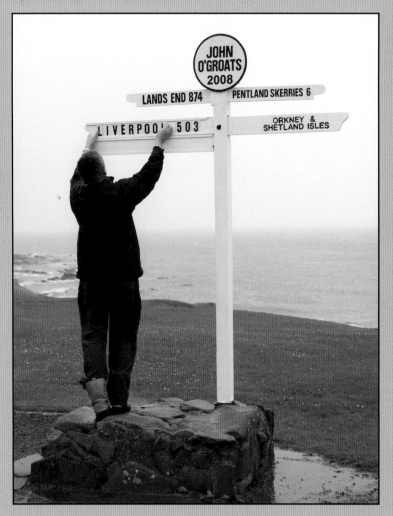

Right. This is a misty Freswick Castle near John O'Groats, run by the amiable and able writer and film director Murray Watts. When he finally converts his castle into his dream of a spiritual retreat for artists and writers he will be a 'miracle maker'… just like the film he wrote the screenplay for.

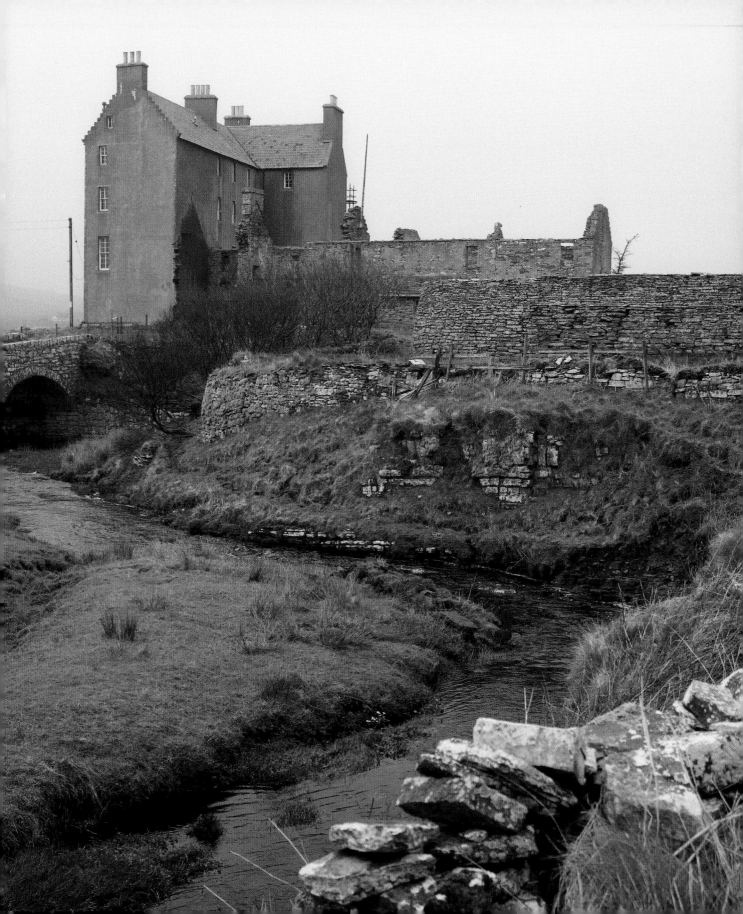

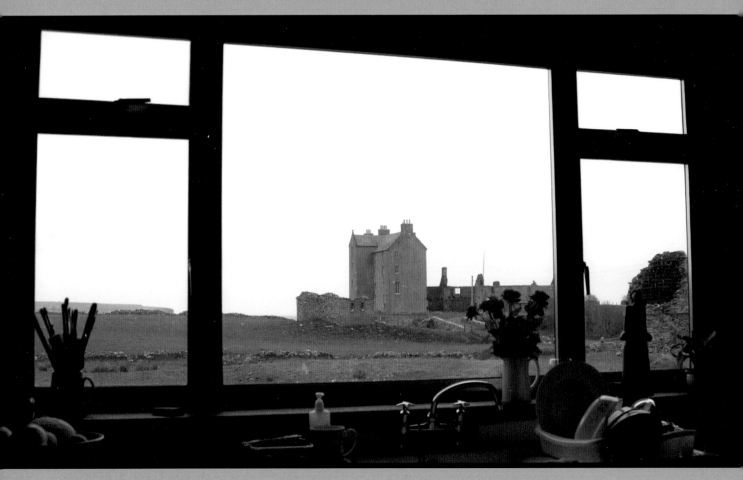

Freswick Castle, taken from Murray Watts' bungalow kitchen ... a little
easier to warm up than the castle!

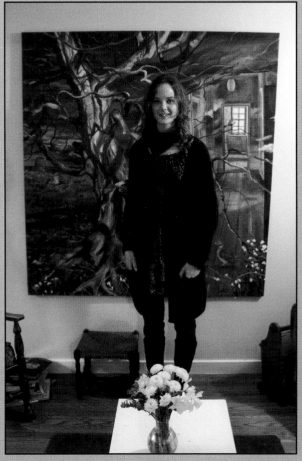

Murray the W's Canadian painter friend Monique Sliedrecht, artist-in-residence at Freswick Castle, standing proudly in front of one of her dream-like, haunting paintings.

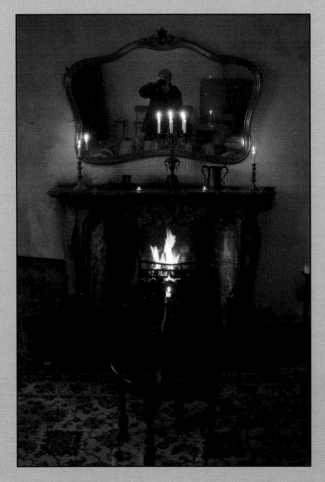

Freswick Fireplace

This self-portrait, an obvious choice for the National Portrait Gallery, was taken in one of the many cool rooms of Freswick Castle.

HOME ... PHONE

When Stephen and Rhona Graham bought a bare croft in Skerray on the north coast of Sutherland they dreamed of an eco home.

Finally, design and planning accomplished, three years ago they began to create their own green castle – from old car tyres, earth, straw, timber and turf.

On the east coast at Golspie stands the more traditional Dunrobin Castle. The 'candle-snuffer' towers of this most northerly of Scotland's great houses can be seen above the treetops from the A9. Home to the Earls and Dukes of Sutherland since the 13th century it has the style of a French château with magnificent gardens – inspired by those at Versailles – laid out in 1850 by architect Sir Charles Barry, who designed the Houses of Parliament.

Dunrobin was inherited by Elizabeth Janson, Countess of Sutherland, in 1963 and today attracts tens of thousands of visitors each year. They will also see the giant effigy of her ancestor, the 1st Duke of Sutherland towering above Golspie, on Ben Bhraggie; the iconic 100-foot high Sutherland Monument can be seen from miles around.

While Dunrobin trades on a rich past, down the road at Invergordon they are tackling the future with paintbrushes. Over the years Invergordon has lost much of its industry – and an important naval base – leaving the town searching for a new identity. Inspired by a success story from across the Atlantic – the Canadian town of Chemainus – and with help from community group Invergordon Off The Wall, residents began to transform the Cromarty Firth town into an outdoor art gallery, reinventing its image with colourful and inventive murals on prominent properties. Now it attracts around 50 cruise liners to the port each year, providing a £7 million boost to the Highland economy.

Talking of Dukes, much further away and small but unique, the 1960s phone box at Achfary in the centre of the Duke of Westminster's 100,000-acre Reay Forest Estate, is the only black and white kiosk in the country.

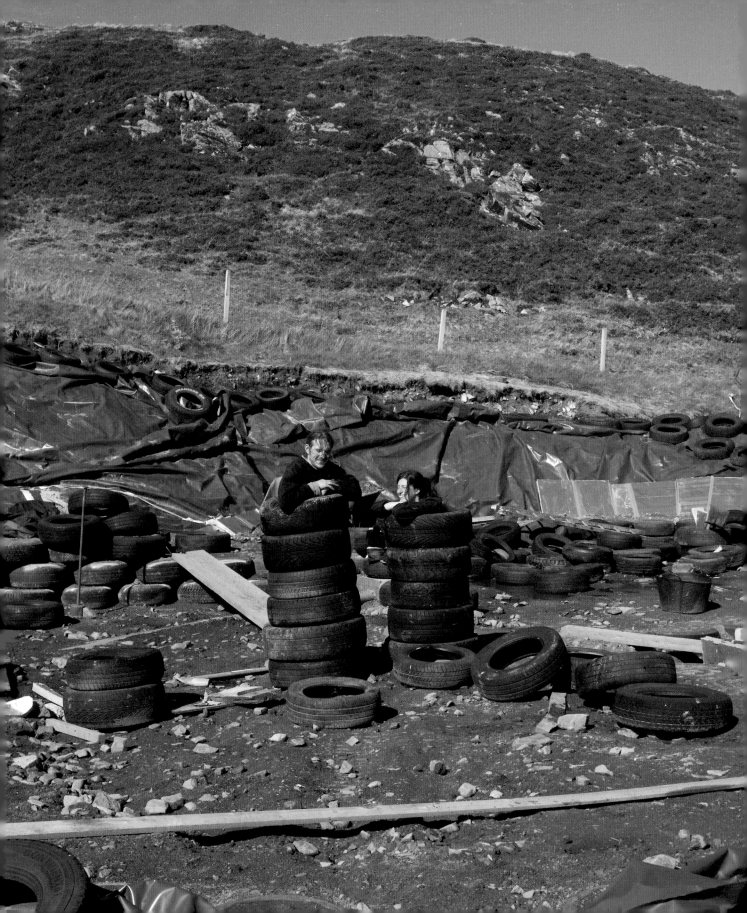

Bike to Dunrobin

I refuse to believe the suggestion that this distant castle is a retirement home for petty criminals, simply because it's called Dunrobin. I'd rather believe this photo, taken through the car window, is Chris Hoy's father cycling into Golspie. Originally known as the Old Man of Hoy, he's now known as the Gold Man of Hoy's Dad.

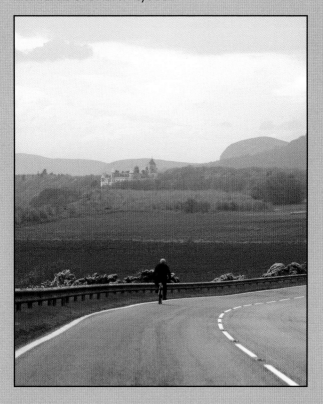

Left. On Sutherland's north coast, this young couple Steve and Rhona are building a house of recycled car tyres and with a straw roof. I did not raise the question of storms (or lightning!) with them.

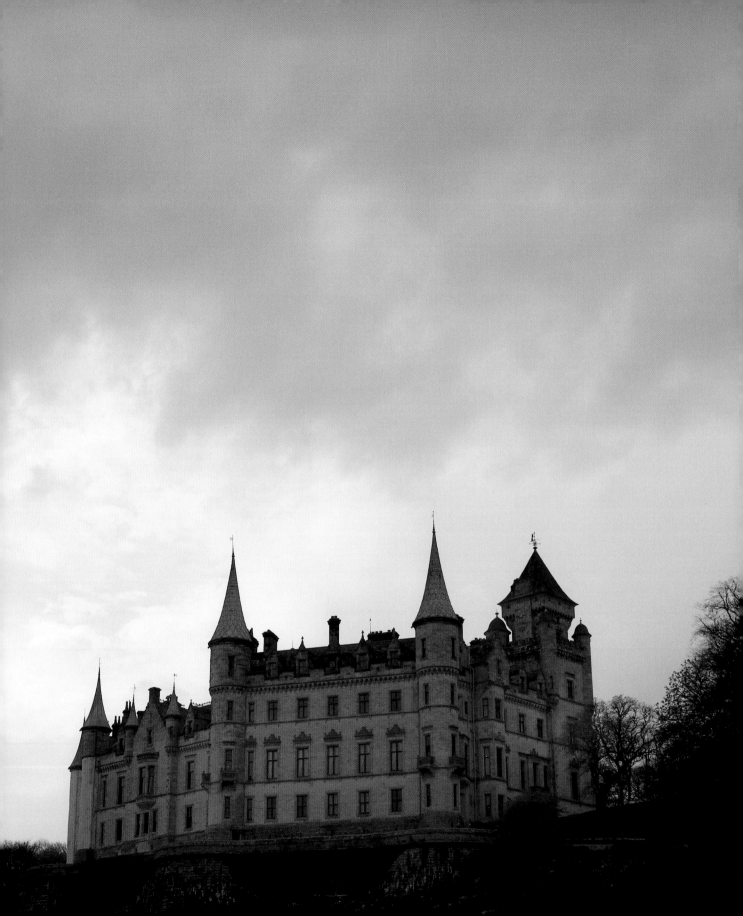

Perched on the top of Ben Bhraggie, behind the Highlands and Islands Enterprise's Golspie headquarters, is the giant 100-foot high effigy of the first Duke of Sutherland. When I die, I have asked my wife Rowena to do the same for me in our back garden.

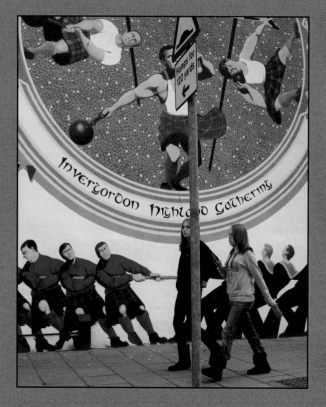

Right. Like Liverpool, when your major industries collapse around you, something has to be done. When Invergordon lost its main employers it turned itself into an outdoor art gallery. They painted stunning murals on the ends of many of the town's houses which, rather like Belfast, is now a highlight for cruise liner visitors. The town that wouldn't die but chose to dye (thanks MM).

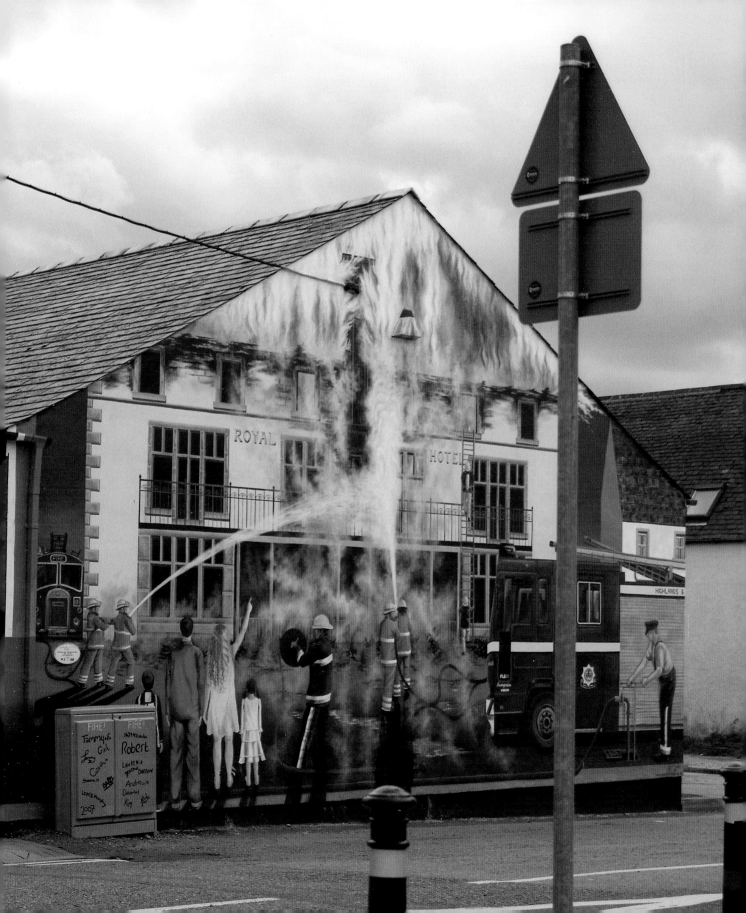

Hi!-land Sheep

When I got out of the car to take photos near Golspie, these poor sheep thought I was the farmer, with their food! Farmer Mike nearly got trampled to death.

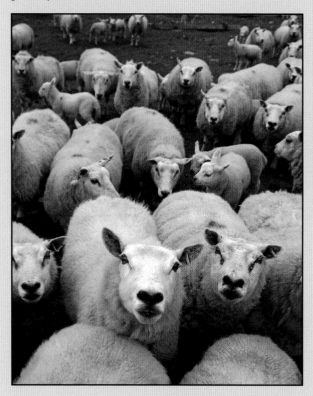

Above and right. Beautiful castles keep jumping out of the North Highlands ... when you least expect them.

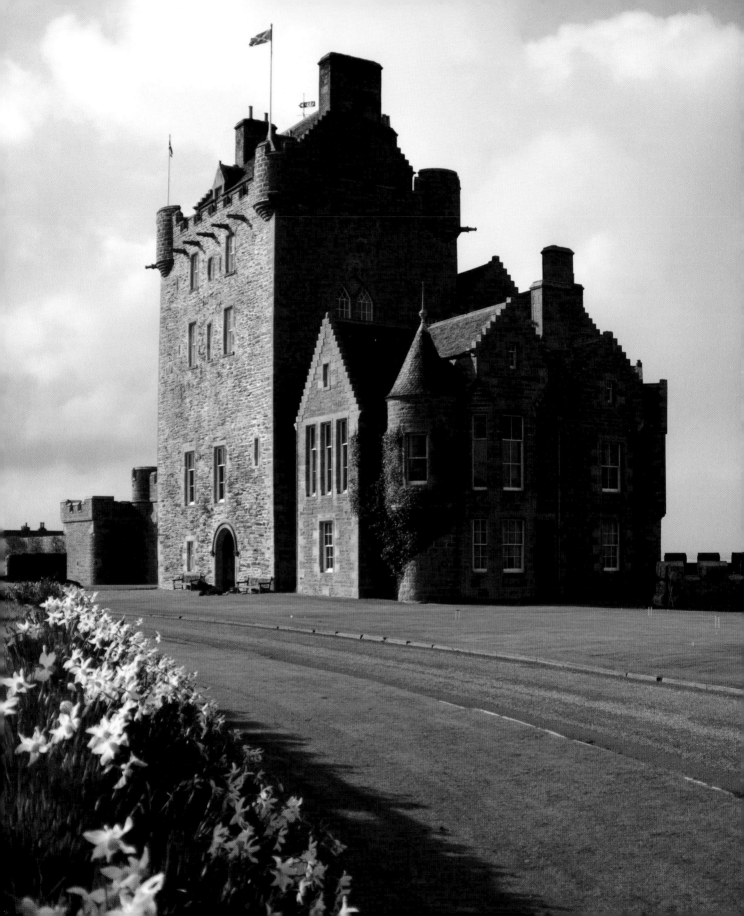

Roadside Whalebone! A little known fact of highland sheep is that at night they sneak down to the sea in packs, catch enormous whales, drag them up to fields like this and strip them to the bone. This is the tail of a whale … or is it a whale of a tale?

The Lady with Seaweed Hair

Whilst taking shots of giant waves crashing against Lybster Harbour walls, I spotted these submerged mermaids, and the lady with seaweed hair sitting below me ... but who are you?

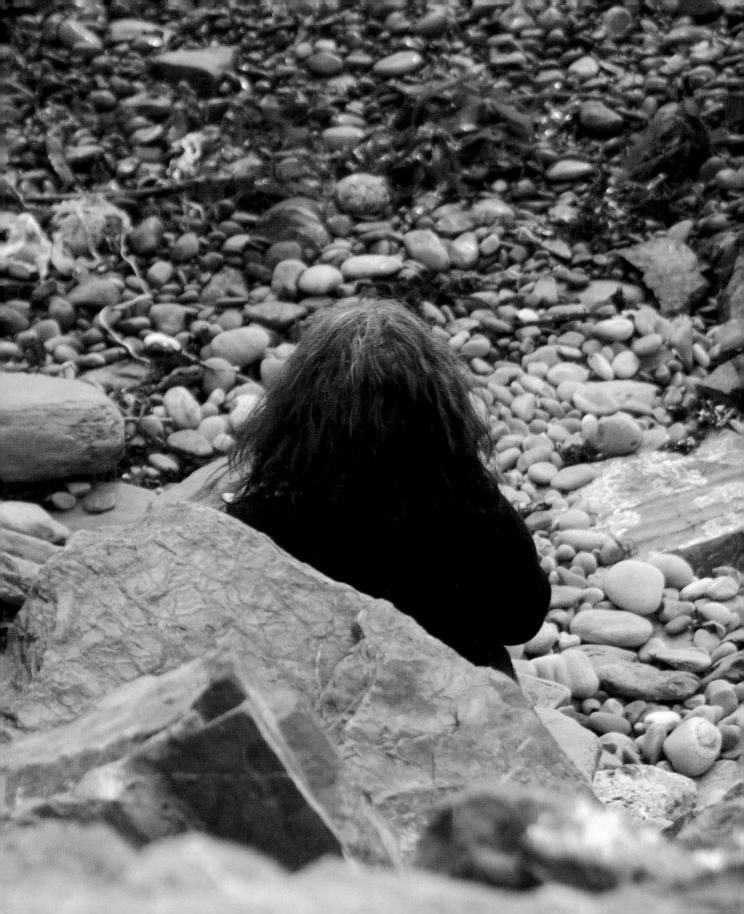

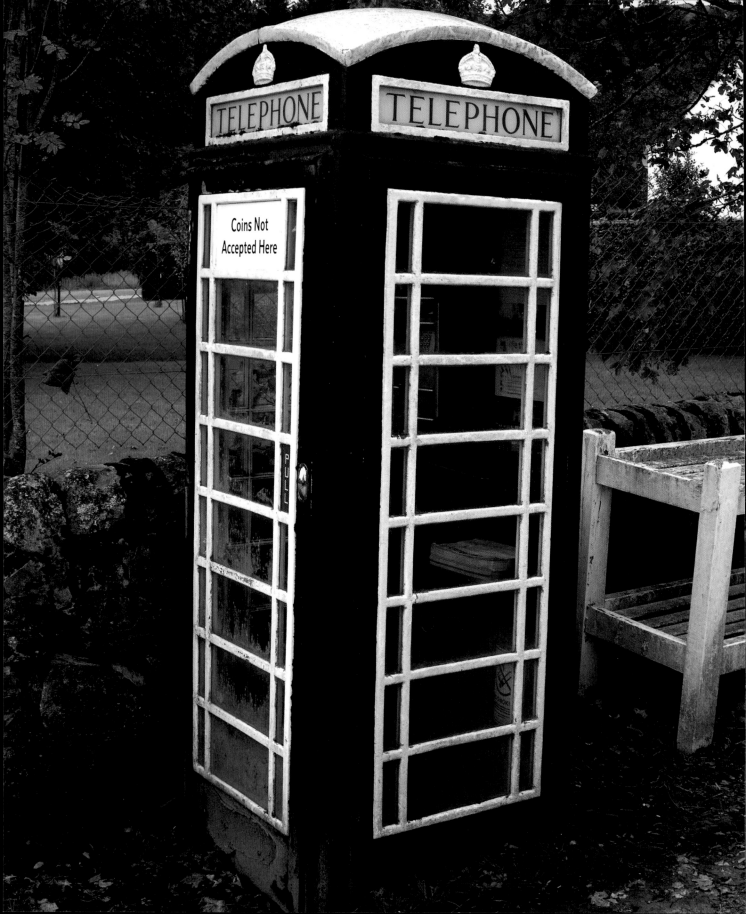

The Black Box

Left.. On the journey up to the northern Highlands I forced my driver off the road in the tiny village of Achfary because "The phone boxes in England are RED." Good job I did … this is the only black and white one in the country, and, wait for it, BT are thinking of axing it! Please don't. (PS Just heard, they didn't. Thank U Very Much).

Michael W Russell (MSP)

Minister for Culture

In the foreword to this quite remarkable collection of images by Mike McCartney, Billy Connolly rightly observes that the Highlands of Scotland pose a particular problem for photographers being, as it were, over-exposed by pictures and films. Sometimes it seems as if, north of the Highland line, there is nothing new to see and nothing but tired and predictable ways of seeing.

But Mike McCartney always brings to his subject matter a fresh pair of eyes and so it is with this collection. Not only does the dome at Dounreay stand out differently from the norm, rising from a ruined farm steading, but so do a putative monarch of the glen, a soaring buzzard and a Scottish distillery worker – to name but three of the transformed personalities that appear here.

As benefits a photographer who made his name – and cut his teeth – in the world of pop music, it is the original and slightly quirky that seems to attract Mike's attention.

That can only be a good thing when it comes to re-presenting an area which many of us know perhaps all too well. We often need to be jolted out of our preconceptions and made to think again about what has become over familiar to us.

In its almost two hundred years of existence the art of photography has gone from strength to strength in what is almost its home country – Scotland. It was the indefatigable Hill and Adamson who invented documentary photography, whilst perfecting the raw techniques which were also being worked on in England and France in that energetic fourth decade of the nineteenth century.

Now as we prepare to enter the second decade of the twenty-first, photography – and imaginative photographers – are still breaking barriers and developing new visions. Mike McCartney echoes a fondness for the north and west of Scotland which is shared by his brother and by at least one other former Beatle, for John Lennon spent his childhood holidays at Durness in Sutherland and often expressed a wish to return there. But Mike takes his affection and puts it to positive use by interpreting what he admires for the widest possible audience.

This is 'his' Highlands but is also a Highlands which is undeniably part of the modern world – glimpsed by sharp eyes and illuminated with keen intelligence. And that is the Highlands which a contemporary Scotland needs to present to the world – a Highlands in which one can retreat from the pressures of everyday life, but which does not condemn its people to be backward or its potential to be unfulfilled. A Highlands that can join in the voyage of modern Scotland, and enhance the ability of the whole to compete. Yet it does so, as these images show, without losing its soul and without sullying its beauty.

Scotland, and the Highlands, need people from other places to help them recognise and preserve what is best about them, just as they need them to help drive things forward. Mike McCartney has performed both those tasks with distinction in the work he has done for this book.

He deserves our thanks.